THE KINGDOM OF MUSIC : ITS RULES, AGENTS AND HISTORY

INTRODUCTION

«*Music is the universal language of mankind.*»
 Henry Wadsworth Longfellow (1807-1882)

And why is music so universal? This is one subject which makes innumerable questions surge up in man's mind. Why is music so absolute and so exclusive? At the exposition of painting or sculpture, or in front of architectural artworks, one can get lost in admiration amidst the different styles and trends which tell him of distinct periods in the history of art – all worthy of consideration and splendid in their own way. Not so in the concert hall. There only one artwork can be admired at a time, imperious and commanding ; its domination is so utter that its only presence excludes all other. Would another piece be heard simultaneously, a dreadful cacophony would ensue, rendering any further enjoyment of the music impossible, even more, making it a source of great annoyance. Music is the only art form which occupies not space, but time, and this particularity allows no two artworks to be performed together. As a compensation, its power on the human heart is without match among the arts: in truth, music transmits a message so important, it can only be understood in complete surrounding silence. Listening to two pieces simultaneously would be as absurd as listening to two speeches at the same time.

In the present work are to be found, firstly, the elementary laws of music in their simplest state ; secondly, the forms, agents and conditions of its making ; and thirdly, a brief, overall view of its captivating history – and the fascinating personalities which, each in their own way, endeavoured to contribute it – until it became what it is in this century. Be it remembered, however, that explaining this strange and unrivalled power of the assembly of sound, is not the object of this book ; but to

open the mind to this magnificent universe, to make it known and better understood, that the secret of its beauty may better be felt by the heart, this is the purpose which the author hopes to have achieved. For no knowledge can ever explain beauty, only pave the way to its discovery.

THE LAW OF MUSIC

WHAT IS MUSIC?

The notes of the scale

Music is an assembly of sounds. In nature sounds can be infinitely different from one another, but in classical music the minimal admitted distance between two sounds is a half-tone. When arranged according to this rule, these sounds are called notes. The notes are contained in a scale. In tonal music the scale is composed of seven notes. Tonal music admits several scales, but in that of C major, the simplest one, these seven notes are the white keys on the piano keyboard, and have been given the names, in germanic terminology, of seven letters of the alphabet : C, D, E, F, G, A, and B, in this order. In latin terminology they have been named after the first letters of each verse of the Hymn to Saint John the Baptist, by the initiative of a Tuscan monk, Guido d'Arezzo. The hymn is as follows :

> **Ut** queant laxis
> **Re**sonare fibris,
> **Mi**ra gestorum
> **Fa**muli tuorum,
> **Sol**ve polluti
> **La**bii reatum,
> Sancte **I**oannes.

The letters of the names appear in bold characters. Consequently the seven notes in latin terminology are : ut (often refered to as do for convenience), re, mi, fa, sol, la, and si.
 As for the black keys on the piano keyboard, they are placed between those of the white keys which are separated by one tone.

They elevate the preceding note of a half-tone, and lower the following note of a half-tone. Thus, for instance, the black key situated between C and D, decomposes the C-D distance into two half-tones. In the rudiments of music these notes are called : sharps if they elevate the preceding note, and flats if they lower the following note.
Consequently, C sharp and D flat are the same note, and so are G sharp and A flat. These so-called alterations, are used mainly in other scales which employ the black keys of the keyboard.

Characteristics of a note

A note is principally determined by four aspects : its duration, its pitch, its volume, and its quality.

The duration is the quantity of time during which the sound is heard. On a score this is indicated by different duration signs, whether it indicate the duration of a sound, or of a silence.

The pitch is the height of the sound, the aspect which makes the listener determine whether it is « high » or « low ». It is indicated on the score by the level in which the signs are placed.

The volume, or loudness, is the amount of power with which the sound is produced. Most of the time it is indicated subjectively on the score, by a written information.

The quality is independent of the three others, and is related to the agent, or instrument which produces the sound. For example, the human voice and a piano do not have the same sound quality.

THE THREE COMPONENTS OF MUSIC

Melody

Whether one whistles a tune or listens to a complete and elaborate piece of music, this is the most important, essential part : melody. This is the very soul of music, that which the listener remembers and can reproduce in his mind or with his voice, long after having heard the piece. For melody is the « horizontal » alignement of sounds, the guiding thread of a composition. Its character is determined by the various distances between the single notes which constitute it. It is the subtlest part, because it is far more difficult to explain why a melody is joyous or sad, than it is to tell why a certain rythm, fast or slow, inspires vivacity or serenity ; and yet the influence of the first is more powerful, as said earlier. It contains this inexplicable substance which is more expressive than words. This is the science of the succession of tones, and the composer appeals, for this more than for any other component, to his inspiration rather than his knowledge, although in tonal music certain rules must be obeyed so as to convey an impression of unity and stay in the chosen scale for the piece. This choice of scale is most important in the character of the succession of notes. In music there exists two different modes which are principally used for the construction of melody : the major mode and the minor mode. Most often the major mode conveys a feeling of joy, peace and tranquillity, while the minor mode inspires sadness, fear and restlessness. In the horizontal organization of melody this distinction is felt in the succession of the notes, as a difference of distance between certain notes. Generally, the melodic part of a piece is played in the treble-clef, the high-pitched notes of the score, by the principal instruments.

Harmony

While melody is the horizontal placement of notes, it can be said in the same way that harmony is their vertical assembly. Melody is the science of the succession of sounds ; harmony is the science of their association. The effect of melody is in the « thread » of the succession of sounds ; harmony emphasizes on the associative effect of sounds. The basis of harmony is the use of chords. Chords are sounds composed of several notes, more precisely, at least three, which are played together, or simultaneously. Chords also have their « melodic » form : arpeggios. Arpeggios decompose chords into the melody formed by the notes which constitute them, played separately or successively. It is thus obvious that chords should also belong either to the major or minor mode. When expressing either one of them the chord is more powerful into conveying the major or minor « feeling » than the melody is, because harmony gains in intensity what it loses in duration. When the sounds are heard together, their respective powers unify themselves to give a greater scope to the feeling they express. It must be noted that an association of two notes is not a chord : two notes are not sufficient. Only three simultaneous notes, at least, can convey a major or minor impression. Generally the harmonic part of a piece is played in the bass-clef, the low-pitched notes of the score, by the more secondary instruments.

Rythm

Rythm is the third important aspect of music. In the common language the term may be used to refer to the accompaniment of the percussion instruments in pop music. But in classical music, this word more specifically designates an invisible element in a piece, nonetheless an indispensable factor and agent in the ensemble of melody and harmony. Its presence does not manifest itself in a « tangible » way, as one could say, but it rules the framework of the piece. Rythm is related to

the notes' duration. In order for music to be harmonious and correctly interpreted, a unity of duration must be established which is the same throughout the piece, and can continuously be marked as a reference in the background. This would be the « beat » or « pulsation ». From this reference a division of time could be made, which would establish the rythm of the piece. For instance, if the piece were divided into sections of three notes of the same duration, the piece would have a rythm of three beats, as would a waltz or a mazurka. If it were divided into sections of two notes the piece would have a rythm of two beats as would a march or a polka. The rythm of a piece is solely determined by the relative durations of the notes in comparison with one another. The duration of each note can be shortened and the beat accelerated so as to conserve the same difference of duration, in proportion : the tempo – as it is suitable to call this « speed » factor – will be accelerated, but the rythm will remain unchanged, that is, the waltz will stay a waltz and the march, a march, although a faster waltz, and a faster march. Rythm is an element which englobes melody and harmony, and the technique of counterpoint such as can be so marvellously demonstrated by Bach's *Art of Fugue*, shows how indispensable, omnipresent, and far from what can ever be rendered by loud percussion instruments, is this third agent.

ELEMENTS OF A STAVE

: treble-clef. This is the clef in which the piece is written. If the interpreter is a high-pitched instrument (or voice), the treble-clef will most likely be used, often for the melodic part of the piece.

: bass-clef. If the interpreter is a low-pitched or secondary instrument (or voice), this is the key to be used, often for the « accompaniment », harmonic – not always – part of the piece.

Andante maestoso : an indication as to the manner in which the piece is to be played. It is, traditionally, an italian term, like this one which means : « moderate and majestic » or « moderate with majesty ». The first term refers to the tempo, the speed with which the piece should be played, while the second more specifically gives an indication on the effect the interpretation should produce.

$\frac{4}{4}$: this is the rythm of the piece. The higher number is the number of beats or time unities in each measure. It has to do with the character of the piece. The number of time unities in each measure determines whether the piece is, for instance, a march (two beats), a waltz (three beats)... The lower number indicates the unity of time used to divide a measure. The crotchet is worth a quarter of the semibreve, which is most frequently taken as unity of value. Thus it is represented by the number 4, because it is a quarter of a unity. The minim, which is worth half the duration of the semibreve, is represented by the number 2, and the quaver, worth half the duration of the crotchet, and consequently, the eighth of a semibreve, is represented by the number 8.

 : the scale's key signature. The signature shows which notes will automatically be altered throughout the piece, except for accidentals (see below). The sharp elevates the note by a half-tone ; the flat lowers the note by a half-tone.

 : an accidental (here a flat) . As indicated by its name, this alteration, whether it be a sharp or a flat, is not natural in the scale corresponding to the key signature. Practically, it will produce an unusual

sound which will sound less conventional – and maybe less « in tune » than the others. The natural sign cancels any alteration. Its shape somewhat resembles that of the flat, with more pointed angles.

♩ : a crotchet or quarter note (american terminology).

♩ : a minim or half note (american terminology).

♪ : a quaver or eighth note (american terminology).

𝄽 : a rest. This is an interruption in the sound. This example is a quarter rest : this means that the sound must be interrupted for a time equivalent to the duration of a quarter note, a crotchet. There thus exists rests equivalent to the duration of each of the notes. The rest corresponding to the semibreve, or whole note, is the whole rest, that corresponding to the minim or half note is the half rest..., etc.

 : a tie. This indicates that the two notes it links must be played without interruption. In other words, it prolongs the note placed before it of the duration of the note which follows it.

 : a semibreve or whole note (american terminology). This is the greatest time unity to be represented by a note. Its duration corresponds to that of two minims, four crotchets, and eight quavers. If the piece is written in 4/4 time, the semibreve is worth one measure.

THE PRACTICE OF MUSIC

THE MAKERS OF MUSIC

The production of a piece of music involves different agents who, each for their part, contribute to create it and allow it to be heard in the world. Here are the principal contributors to this elaboration, those most closely related to the performance which then takes place before the grand public.

The composer

Assuredly, the main force in this work is the composer. The piece can rightly be called his and his alone ; for he is the creative force, the one who devises the music and writes on the score every one information and indication necessary for the work to be performed in the way he intends it to be heard. The image of the composer, and above all when refering to History's great composers, has long been mystified as a result of the aura of genius and almost divine talent apparently bestowed on them. While it is more and more acknowledged in present times, that composing is within anyone's reach – and that it was an art naturally practised, even in the past centuries, by all or most of those who were called « musicians », as a branch of their profession – the fascination exerted by the image of the greatest composers of our humanity, still remains, and will do so forever, because their extraordinary inspiration appears as magical to us, and rightly so.

As presupposed by this, the capital factor in the invention of a piece of music is inspiration. Of it depends the value of the idea which constitutes the framework of the piece. Inspiration is an element very much personal and subjective, and the question of its source can continue to puzzle the learned and the layman alike as they attempt to determine its origine.

If inspiration surely is the most important condition for a piece to be of value, knowledge of the elementary rules of music is also indispensable to the composer. In order for the structure to allow the

principal idea to blossom and be highlighted, it must be well-built and efficient. Knowledge of the principles of melody, tonality, harmony – the science of chords –, rythm, gives the composer the capacity to express what he wishes to express in his work, in a manner if not agreeable at least understandable to the listener, and even more, it may considerably help the less inspired in producing a piece at least worthy of being heard. The principle is simple : the composer, with or without the help of an instrument to find the notes and verify they make the desired sound effect, writes the symbols which, in the musical language as we have seen, correspond to his ideas, with the additional necessary information for its execution, the intended interpreters and the precisions on how the piece is to be performed. Composing is certainly the noblest and most revered achievement of a musician, and the importance of the composer will surely never be overly emphasized.

The interpreter

Here is the second most important agent in the music creation process. While the composer creates the complete work in advance, and establishes it, as it were, in a « fixed » form, the performer is responsible for its « live », « material » appearance, that is, its performance in front of the public. For that reason nowadays the image of the interpreter tends to be emphasized compared to that of the composer. In fact, the less precise are the indications of the composer on his score, the more personal becomes the interpretation of the instrumentalist or singer. All that the composer has omitted to indicate on the score, is left to the good taste and judgment of the performer who will present the piece to the public. This is why two performances of the same work may greatly vary according to the different tastes of the interpreters.

To begin with, the performer can either sing the piece, using his voice, or play it using an instrument. Some instruments, as will later be seen, have the capacity to produce the melody and the accompaniment at the same time, and can consequently be played without any other, in « solo » as it is said. Other instruments, like the voice, need a second

instrument to accompany them as they are unable to produce the melody and the accompaniment all at once. It ensues that the performer can be either alone in front of the listeners, or accompanied by one or several others.

Then, the performer can also be the composer himself, as it frequently happened in the Baroque, Classical and Romantic eras when the composers themselves introduced their compositions in public. Usually the composer is proficient in the instrument for which he writes, and if he is a virtuoso in some instrument he is likely to write pieces for this instrument. Sometimes it happens however that the composer, even good at playing his instrument, writes a virtuosic piece that even he himself cannot play ; he then must resort to a professional interpreter, a virtuoso, to interpret his work in public.

The full knowledge and complete understanding of music law is essential to interpret a piece, correctly and steadily as the composer intended. Before playing on an instrument, or singing, the piece, the performer must be acquainted with it by reading the symbols on the score. The score indicates everything the interpreter has to know to play or sing the piece correctly. When this is attained, the interpreter can reproduce it on the instrument, if the piece is instrumental. This is the next step in the interpretation process. Virtuosity is the point when all technical difficulties have been overcome and the player is capable of playing any piece without physical obstacles.

In determining the ability of a performer to play a piece, there still remains one factor to take into consideration, which makes the link between the skills required to read a score, and the technical skills demanded to play the instrument. This factor is the capacity to associate what is read on the score and the movements of the hands on the instrument, necessary to reproduce it. Consequently, this ability comes from the simultaneous capacities of reading on the score, and playing on the instrument, what is read. When this is brought to such a degree of perfection, that the interpreter can read and play at the very same time, this is called sight-reading. The performer can play a piece almost without practicing beforehand if he sees the score.

To illustrate this an example can be taken. Let us imagine a musician who disposes of a score and an instrument. He may be able to read and understand the language of the score ; he will « hear » the music mentally, without however being able to reproduce what he sees on the score on his instrument. Now if this musician were, on the contrary, a

virtuoso on his instrument, capable of surmounting any technical difficulties and of producing any note on the instrument, but not proficient in reading the score, he would be able to play anything of his own invention, but he will not be able to use any partition to play music which is already written down, nor will he be able to write down, his own inventions. Finally, would this musician be both an expert at sight-reading, and a virtuoso on his instrument, he would be capable of playing anything provided that he dispose of a partition, and a musical instrument, the one on which he is proficient. He would, moreover, be able to play the piece while he reads it on the score.

To this the capacity of improvisation must be added, that by which the improviser is able to create a piece while playing it, without having written it down first. This demands not only a thorough knowledge of the instrument and of music law in general, but also, a formidable amount of good taste and inspiration.

The orchestra

The orchestra is an ensemble of performers who associate with each other in the performance of a piece written for multiple voices. As there are various levels of compositions there are also various kinds of orchestras. On the grand scale there is the symphony orchestra, and on a smaller level there also exist chamber orchestras, more limited orchestras of approximately fifty or less musicians, while the symphony orchestra can be twice as large. In this domain must be introduced another essential contributor to music-making : the conductor.

The conductor

When a performer wants to play a piece of music, he must learn to coordinate the movements of his right and left hands in order to achieve

unity of melody and accompaniment. But when a whole orchestra joins, with all the instrumentists it contains, to play in unison, then the problem is quite different. In this case the coordination must be achieved not only between the two hands of the performer, but between all members of the orchestra. This is when the conductor intervenes.

The question of the role and importance of the conductor has been examined and debated throughout the history of music. Almost every musician, whether he be a composer, a renowned conductor or even a performer, has his ideas about what should be done by the conductor in conducting an orchestra.

Traditionally, the conductor stands on a podium facing the orchestra, with or without a baton in one hand. His function is to establish the tempo of the performance, guide the instrumentists that they all begin together, and indicate the manner and temperament with which each passage is to be played. He must be the uniting force in the orchestra, and as such he must ensure the coordination of the performance. A conductor, often a fine instrumentist himself, knows the part of each instrument in the orchestra. In front of him is a partition containing the score of each of these parts ; he can thus signal the musicians when they must enter in the piece.

The conductor being as important in an orchestral performance it is easy to understand that a piece differs widely according to under whose baton it is played. The conductor is, in a sense, the « performer » of the orchestral piece, the one who gives his own version of the work, as the pianist is for the solo piano work, for example.

The past century has produced countless great conductors, among which stand as towering figures, Herbert von Karajan, Leonard Bernstein, Arturo Toscanini, or Claudio Abbado. They all have their own characteristics and originalities : some prefer to be as moderate and discreet as possible, hardly moving their arms as they guide the orchestra, and being content with finger cues, while others are more expressive, and indicate the character of the passage with extroverted gestures of the arms and the body. Also, some believe the role of the conductor confines itself to giving the orchestra the appropriate tempo at the beginning of the performance, and guide them through particularly difficult or expressive passages, otherwise giving the performers relative independance ; others think it necessary to not only accompany the orchestra all along the concert, but also indicate precisely how each passage of the work should ideally be interpreted. Be they for one method or another, all the

conductors are valued and remembered for their personalities and originalities in introducing to the public the music on the grand scale.

THE INSTRUMENTS OF THE ORCHESTRA

In the preceding pages the orchestra has been abundantly mentioned with frequent allusions to the performers who constitute it. In fact, all these performers are not identical in their function and means of producing the music. An orchestra is a complex assembly of different voices. As has been said in the first part of the present work, on music law, the three first aspects of a note, duration, pitch and volume, are determined solely, apart from certain limitations, by the manner of execution of the note, which is left to the performer ; but the last aspect, quality, depends on yet another factor, and this is the instrument by which the note is produced. And this is the purpose of the various instruments which man, in his quest of sound, has devised. By associating different instruments in an ensemble, the harmony of a piece of music has yet been brought to a greater level of beauty : that created by diversity. This association, is the orchestra.

By creating all these instruments and making them work together it has been possible to make music even more expressive, as a melody will have a different impact according to the tone quality of the notes which constitute it. A composer can emphasize the meaning he has desired to give to a succession of note, by choosing the instrument which will best convey this meaning. We shall focus on three principal classes of instruments : stringed, wind, and percussion instruments.

The stringed instruments

Stringed instruments are instruments which produce sound by the

vibration of their strings. Since Pythagoras found that the reduction of a string of half its length, elevated the pitch of its vibration by an octave, instruments functioning according to this principle, have been created using also the thickness, weight and tension of the string, which are all factors in the pitch produced.

Stringed instruments can be said to be the champions of the orchestra. They are placed in front of all the others and are the dominant section in the ensemble. In the orchestra, the string section is mainly constituted of four instruments : the violin, the viola, the cello and the double bass. All the four previously mentioned instruments are principally made from wood, and assume, approximately, a similar appearance. Here below is a brief descriptive of the stringed members of the orchestra.

Violin : the violin is justly called the king of the instruments. Indeed, it is the symphony orchestra's most important member. The violin section is placed at the front of the orchestra, forming a group around the conductor's podium, on the left, facing the cellos. The principal themes of almost all orchestral pieces are carried on by the ensemble of the violins which leads the others. The first violins are the real leading instruments. Their abilities allow them to reach particularly high notes and shine through all the most moving and dramatic passages, while the second violins have a more accompanist role.

Physically, the violin has established a model for all its lower-pitched cousins : a curved wood soundboard, usually made of spruce, which serves as a support for the strings tied against the neck. It is one of the most beautiful musical instruments, and also one of the most fragile. Its delicacy, incredible versatility, and the use of the bow to operate the strings allow an unequalled subtility in the tones, and make possible for the player to slightly modify the volume, depth, and quality of the sound while it is produced, an asset offered by few other instruments.

Viola : here is the alto of the string section. It is almost similar to the violin in appearance and manner of playing, and is close in tone, only a little larger and slightly lower in pitch. Dating from approximately the same time as the violin to whose family it belongs, the early 16th century, it has gained a secure place in the orchestra since size problems have been resolved.

Cello : this is the bass of the string section. Like its cousins it dates from the 16th century, and like the viola which sounds an octave higher, its main problem was its size. Since its beginnings the size of the cello has been considerably reduced and from this moment on it has become an

undisputed member of the orchestra, not only accompanying the violin and viola, but also standing out in solo or orchestral pieces like cello concertos.

Double bass : the pitch of this instrument is so low, that its use and effect approach from those of percussions. In fact, the tones can less easily be distinguished from one another, and their heavy, low vibrations mark the rythm of the piece. In appearance the double bass resembles the violin with some slight differences of shape, but is the largest member of the violin family. It is also played with a bow, and the strings can be plucked like those of all stringed instruments.

Beside these four another stringed instruments holds an important place in the orchestra : the harp. Unlike the components of the violin family, it is not played with a bow but with the fingers, and there are, instead of four strings, fourty-six, which enable it to cover a larger compass of tones. The sound of the harp is unique in its mellow softness, as is its appearance : an upright, narrow instrument with strings aligned, beside the player, in front of one another instead of next to each other. The harpist sits behind his instrument and plucks the strings with the fingers of both hands.

The wind instruments

Just as stringed instruments depend on the vibration of their strings to make notes, wind instruments produce sound with the vibration of the air inside their pipe. This vibration is provoked by the blowing of the musician who places the mouthpiece of the instrument between his lips. Thus work the wind instruments : the longer the distance through which the air travels in the pipe, the lower the pitch will be, and conversely the shorter the distance, the higher the pitch will be. Thus also, and according to this principle, are used the various holes in the pipe of the majority of the wind instruments. The player places his fingers on the holes to obstruct the air exits in order for the air to travel the necessary distance to produce the desired note. This is the principle of nearly all the wind instruments and of the entirety of those which are commonly used in the orchestra.

Wind instruments are themselves divided into two classes : woodwind and brass. The first class is composed of four main instruments : the flute, the oboe, the clarinet, and the bassoon. They are thus called because they were originally made entirely of wood, and have retained this appellation ever since even if today this is not strictly true. The second class consists of four instruments : the trumpet, the trombone, the horn and the tuba.

Below is a summing up of the outstanding characteristics of the woodwind, followed by those of the brass, instruments of the orchestra.

Flute : when using the term « flute » in the context of the orchestra it is generally refered to the transverse flute, whose first appearance in the orchestra dates from the end of the seventeenth century. Its name apparently results from the way in which it is played : the flautist holds it to his right side, his mouth on the left extremity of the instrument, where the mouthpiece is, and his fingers on the willowy body, where the holes are. The material is not wood anymore, but mostly silver which is thought to allow a more expressive tone.

Oboe : the term « oboe » comes from the French word « hautbois », which means « high wood ». This appellation well evokes the characteristic spindly tone of the instrument. At least as ancient as the transverse flute, the oboe came to evolve through many improvements in its construction, getting from a two-keyed to a four-keyed design, with modifications of the size and position of the fingerholes, and changes in the construction of the reed and bore. Different varieties include the cor anglais, the oboe d'amore, the baritone oboe and the heckelphone, all lower in pitch than the traditional oboe.

Clarinet : resembling the oboe in appearance, the clarinet has a deeper, fuller tone. Dating from the beginning of the eighteenth century, it has, like the oboe, undergone many modifications until the sixth key was added at the end of the eighteenth century. Due to the problems of fingering and intonation several varieties exist in different pitches, and various types include the B flat, A, B and D clarinets, as well as the bass clarinet.

Bassoon : as its name may indicate, the bassoon is the bass of the woodwind instruments. It was called thus since the beginning of the seventeenth century, before it became what it presently is. Larger than the other members of the woodwind section, the bassoon is straight like its cousins but its lower-pitched variety, the contrabassoon, is curved and terminated by a metal bell-shaped section.

Trumpet : here is one of the most ancient instruments of music, and certainly the most popular of the brass section. Dating from as early as the time of the peak of the ancient Egyptian civilization, the trumpet has mostly been used as a military instrument before being inserted in the classical orchestra. Like all members of the brass section its end is bell-shaped, and like the clarinet it exists in varieties of different pitches.

Trombone : the trombone was created in the middle of the 15th century as a lower-pitched cousin of the trumpet. In appearance it resembles the trumpet, but possesses a slide which makes it look more willowy. Its sound is slightly more « stifled » than that, somewhat shrill, of the trumpet.

Horn : as much in shape as in manner of use, here is a most peculiar instrument of music. Its pipe winds in endless convolutions which assume the basic form of a circle, its keys are built to be activated by the left hand, and its bell-shaped end faces the rear of the orchestra. It has traditionally been used for hunting and signalling in the postal service in the 15th and 17th centuries, but its expressive, mellow and particularly soft tone makes it the most melodious member of the brass section.

Tuba : just as the bassoon is the bass of the woodwind section, the tuba is the bass of the brass section. The types used vary according to the countries, from the F tuba preferred in England and Germany, to the C and B flat tubas of Italy and the United States, or the even larger tenor C tuba used in France. The tuba is mainly a military band instrument, and its insertion in the orchestra has served romantic and grand scale music. Physically the instrument is somewhat like a large trumpet, with the bell turned upward and the mouthpiece directed horizontally towards the player's face. The tuba has found the fullest exploitation of its potential in jazz, 20th century and avant-garde music.

The percussion instruments

The percussion instruments are related to the third aspect of music as has been stated previously, the rythmic aspect. It ensues that this category does not demand an elaboration as precise and subtle as that of the two others, for most of the instruments belonging to this category, do

not produce various notes as necessary to constitute a melody. This brings the necessity to differentiate two types of percussion instruments : those which produce a definite pitch, and those which do not, and are thus strictly rythmic instruments.

Among this first group can be distinguished three main members : the timpani, the cymbals, and the xylophone. The other group contains the bass drum, the tambourine, and the triangle. Of course this list is far from being exhaustive, as the number and variety of percussion instruments susceptible of being used in an orchestra, are particularly vast. The following descriptive will focus on these six instruments.

Timpani : those are the most important and elaborate members of the percussion section. They present the advantage of having the capacity of being tuned to a determined pitch. This particularity enables them to serve melodic, aside from rythmic, purposes. After having been used, in their ancient form, by the nobility and the cavalry regiments, timpani entered the orchestra around the beginning of the seventeenth century. However this « upgrade » from which they benefited, required them to meet certain standards to which they were adapted through a series of modifications. First they had only to be tuned to a different pitch, but by the end of the eighteenth century, this pitch was also required to be changed in the course of a performance. As this took a certain time, numerous attempts were made to facilitate these manipulations. The modern timpani is provided with a system of pedals which enables the player to change the tune while playing.

Cymbals : the cymbals are not originally instruments of melodic capacity. They started as ceremony, then martial instruments, but some time after they were introduced in the orchestra in the eighteenth century, they began to be used more subtly especially since the 19th century when composers started tuning them to various pitches. The cymbals present themselves as two circular plates, usually made from copper, which the player clashes together, in different ways according to the effect desired.

Xylophone : this is an instrument rarely used in the orchestra, whose repertoire is quite limited. It was late in being inserted in the orchestra, only near the end of the 19th century. Physically, the xylophone is somewhat resemblant to a keyboard, with the frame covered by blocks made from wood, and aligned together, either placed on straw or fixed to the frame. The variations of pitch are obtained by the difference in the length of the pieces of wood. The wooden pieces are struck with two beaters, one for each hand of course, whose constitutive material may

vary. Compared with its cousins in the percussion family, the xylophone is a very melodic instrument, which can both produce enjoyable solo pieces, and provide a fine accompaniment when included in an orchestra.

Bass drum : like all bass instruments, this is a large variety among its cousins. A percussion of indefinite pitch – which cannot therefore produce melodic effects – it presents itself as a large cylinder elevated on a stand, its circular surfaces facing the sides. The player remains standing, and strikes the circular surface with a single beater. There are many different sorts of drums, among which the military bass drum, the gong drum, and the giant bass drum.

Tambourine : the tambourine is simply another variety of drum. Unlike the bass drum, it can be held in one hand and assumes the shape of a hoop to which are fixed round metal jingles. The jingles are attached loosely enough to be set in motion when the player shakes or strikes the hoop. They resound with a shrill tone when thus shaken. A very ancient instrument going back to the Roman Antiquity, the tambourine has, on the whole, retained its original form ever since.

Triangle : this member of the percussion family was not introduced in the orchestra before the eighteenth century. First used for folk dance and music, it was considered a lowly and unworthy instrument, until more and more composers scored for it and it became a regular member of the symphony orchestra. In appearance, the triangle is similar to an equilateral triangle, made of a steel stick whose extremities are not joined on one side. This enables the stick to vibrate more freely and completely. It is suspended to a thin thread and struck also with a steel stick.

Other non-orchestral instruments

Aside from the orchestral instruments described above, there also exist very well-known instruments which are not a part of the common orchestra. The title of this subchapter does not signify that these instruments are never inserted into an orchestra, but their capacity to produce both the principal voice and its accompaniment – they are called « harmonic » instruments because they can produce chords – or there particular nature make them suitable as solo instruments. Apart from

orchestral pieces where their presence is necessary, concertos are the principal musical forms in which these instruments are exploited to their full potential and truly allowed to shine, in a sort of dialogue with the orchestra. Below are described the principal instruments which can be said to belong to this category.

Piano : among all modern instruments and those created until our times, the piano is certainly the most popular and appreciated. Several reasons can be brought forth in explaining this popularity attained by few other instruments of music. The sound of the piano is profound, neutral enough to be able to express all the particular feelings and effects which are intended to come out of a piece. This neutrality and, at the same time, this expressivity allow the piano to be used in an infinite range of musical forms and varieties, from grand scale, imposing orchestral pieces to intimate chamber and solo music. Also, the width of the piano keyboard allows it to cover eight octaves, making it one of the widest ranges among common instruments. Moreover, this keyboard is made of keys which only need to be struck to produce the correct sound ; consequently the piano is one of the simplest instruments to learn for the performer, and often the beginner's introduction to the rudiments of music : indeed, the very disposition of the keyboard is favourable to enable the student to envision more clearly the relative positions and intervals of the notes of the various scales.

Basically, it can be said that the piano is a hybrid between a stringed and a percussion instrument, as the sound is produced by the striking of hammers on extended strings of varied length and thickness. The first piano was made at the beginning of the 18th century by a harpsichord maker, Bartolomeo Cristofori, but it was called pianoforte and its sound was rather far removed from that of the modern grand piano.

There now exist two principal varieties, the traditional grand piano, in which the strings are extended horizontally, and the upright piano, invented later for space problems, in which the strings are placed vertically and which is far shorter in length, than the grand piano. The pedals act on the hammers to modify the sound, allowing either to prolong and deepen the note, or to muffle it.

Organ : the organ is one of the most beautiful ornaments of the church. And when its powerful and majestic sound echoes against the walls of a cathedral, with its massive size and elaborate construction, it is indeed surprising to note that this is a very ancient instrument, dating

from the third century BC. Designed like a keyboard, the organ is in fact a wind instrument, whose keys activate a system of air supply. The air is blown through pipes of different length which each produce a distinct pitch.

There also exist different varieties of organs, among which the portative organ, a small instrument which can be played suspended around the neck – with one hand on the keyboard and the other activating the bellows – as a folk organ ; and the positive organ, used in some churches as a replacement of or supplement to the large organ, small and light enough to be moveable. Traditionally and mainly a church instrument, the organ can also be inserted in homes ; its « domestic » variety, the house organ, is a splendid ornament to spacious interiors.

The sound of the organ is shrill and profound at the same time, and capable of imitating the tones of various instruments according to the choice of the organist. Its tone produces an echoing and heart-searching effect, above all when it makes the walls of a whole cathedral vibrate. As if invisible, intangible sounds were more powerful than tons of matter.

Guitar : if it had not been so enthusiastically used as a folk instrument because of its favourable size and construction – which provides the player with an ideal accompaniment instrument, its six strings making it easy to play in a method of chords – the guitar would surely have a place in the orchestra, even though, as a classical instrument, it is much better known in the repertoire of solo pieces. Like the piano and the organ, it is a « harmonic » instrument, capable of providing alone the melodic part and accompaniment of a piece, and this is perhaps another reason why it was never inserted in the symphony orchestra. Concertos for the instrument are rare in the repertoire, but it can be substituted to any instrument by means of transcription, as it is, like the piano, a « miniature orchestra in itself ».

The guitar belongs to the string family, its system of strings being similar to that of the violin. Unlike the violin however, the strings are plucked by the fingers instead of being sounded by a bow, and all strings are on the same level : they are not maintained in a curved position as those of a violin. The guitar family also comprises many members, among which the mandolin and the lute, whose sound is very much like that of the guitar. The lute presented the inconvenient of being difficult to hold and to tune, and its strings of breaking easily.

The guitar's solo repertoire was constituted by mainly Spanish and South American composers : Fernando Sor in the 18th century, Francisco

Tarrega in the 19th century, Andres Segovia at the beginning of the 20th century... And it is surely thus that the guitar shines most, in solo, with nothing but silence to accompany its mellow and melancholy tone.

THE MAIN MUSICAL FORMS

As there exist various literary forms – such as the novel, the short novel, the fairy tale, the newspaper article – so music comes in different forms according to the aim and intention of the composer in creating his work as well as the dimension he wants it to take in the eyes – or ears – of his audience. Recognizing the many musical forms allows a better appreciation of each of them, for it is in knowing what is supposed to come out of a work, that one is able to appreciate and judge its worth and genius.

The Symphony

The term « symphony » comes from the Greek « syn » which means « together », « group », and « phon », which means « sound ».
Consequently a symphony is a work which involves an entire orchestra, in the sense that all the instruments of a classical orchestra are needed for its performance, but also that no instrument particularly stands out from the ensemble, unless there is special intention of the composer to do so. Even then it will only be temporary, for the object of the symphony is to create harmony of sound by exploiting the associative and expressive properties of each instrument.

The traditional form is the four-movement form, with the first movement as an introduction to the whole piece ; the second movement, often slow and pensive in character ; the third one, more joyful and

carefree ; and the fourth one, a finale, the victorious, often lively conclusion to the work. The aim of the first movement is to arouse the audience's attention. It can thus be a lively, captivating and enthusiastic opening, but it may also be a slow, mysterious and majestic introduction, as long as it catches the attention of the ear. The second movement is generally slow and thoughtful in mood, a quiet and restful, but also sometimes painful, interlude to the work – like a peace haven in the midst of the turmoil. It introduces a lighter, sometimes pompous and sometimes mischievous, third movement. The fourth movement is the finale, ever glorious and victorious with its tones of triumph. In the symphonies of the Classical Era the first and last movements are generally observant of the sonata form. This means that the piece is thus constructed : an exposition of the themes which constitute the piece, is usually repeated, this part is called the exposition, and is usually played two times ; the themes are then transformed and introduced in a new manner, this is called the development ; finally the recapitulation reunites all the themes for the outcome which leads to the conclusion. Still in the Classical symphony, the third movement is generally a minuet, a measured, courtly dance whose elegance cheers up after the profoundness of the second movement.

 The later symphonies of the ninteenth century, and the Romantic and late Romantic symphonies, break up with the sonata form. The third movement is no longer a minuet but a usually cheerful, recreative respite in the piece, somewhat retaining the spirit of the Classical minuet, its ancestor. Of course there are frequent exceptions to the rules above established, as some symphonies have more or less than four movements (most early symphonies of the beginning of the Classical era and even later ones are in the three-movement form), and certain symphonies have slow first and third movements, and a fast second movement.

The Concerto

 Like the symphony, the concerto involves an entire orchestra. But unlike the symphony, it does bring out a particular instrument, which

« converses », so to speak, with the orchestra, taking up the themes the latter introduces, and developing them in the measure of its capacity. The object of the concerto is to highlight the solo instrument by exploiting its potential to the highest possible degree, and it thus becomes evident that the soloist must always be an accomplished instrumentist, mastering his instrument to a high level of perfection.

The traditional form is the three-movement form, a structure less frequently varied than that of the symphony. The first movement is an introduction destined to present the instrument and install the atmosphere. Here the entry of the solo instrument is particularly important, because it must draw the attention on its qualities and special characteristics by contrast with the orchestra. Sometimes the solo instrument introduces itself by restating the theme first exposed by the orchestra, but sometimes its personality is further highlighted by its entering with a new theme not beforehand presented by the orchestra. Usually the orchestra begins, but in some rare cases it is the solo instrument which precedes the orchestra.

The second movement is most often slow, a romance or a slow march to exploit the tender and cristalline quality of the solo instrument.

The third movement is the finale, where soloist and orchestra seem to join to jubilate in a joyous conclusion to the work.

The first movement generally, and the second and third movements more occasionally, end with a cadenza, a final display of virtuosity in which the orchestra is silenced and the solo instrument, alone for the first time, enters into a dazzling improvisation tour de force on two of the principal themes of the movement before the orchestra returns to bring the work to its triumphant conclusion. It must be noted that this part has been left for the soloist to improvise until around the second half of the 18th century, when composers began preferring to write the cadenza themselves, in case of the lack of taste of the performer.

The Overture

The term « overture » somewhat sounds like a phonetic rendering of the French word « ouverture » which means « opening ». The overture is,

as its name indicates, an opening piece which can begin a performance. It can be a concert overture, and if so, it will open a concert without necessarily having any connections whatsoever with the pieces played.

Then there is the opera overture, which introduces the work and is played before the curtain opens. Sometimes a prelude before each or certain acts is preferred to the general overture, usually longer and less introverted. Being an opening piece, the overture must put in the mood of the work to come, and is characteristically striking, whether by an expectant quietness and gravity, or a joyful or dramatic energy and liveliness, or even a slow and solemn beginning, followed by a contrasting, fiery burst of enthusiasm and dynamism to announce the drama which will take place. The genre of opera will be defined later on.

Chamber music

Not all musical forms involve an entire orchestra. Some pieces are written for an ensemble of six or less instruments, and some are destined for a solo instrument. An ensemble can be composed of stringed or wind instruments, or both, or even a keyboard, most often a piano. If it contains six instruments, for example, one double bass, two cellos and three violins, it will be called a sextet. In the same way an ensemble of five, four, three, or two instruments will be called a quintet, a quartet, a trio, or a duet. The nature of the instruments which constitute the ensemble can be specified in the name of the piece : so there are string quintets, wind quartets, piano trios, or sextets for winds and strings, and so on...

The pieces for solo instruments are varied in their forms. The piano and the organ, among others, are privileged in that they can supply for an orchestra because, as has been seen in the preceding chapter, they are capable of producing chords and allow to play with several voices, the melody and the accompaniment.

The Sonata

The sonata is a little symphony for one instrument. It can also involve two instruments, like violin and piano. It usually comprises three or four parts with innumerable exceptions to this rule. The character of each part is, on the whole, similar to that of each movement in the symphony : the first, an opening, the second, a usually slow interlude, the third, often a light-hearted « joke » – as the word « scherzo » means in Italian – and the last, a finale.

In the domain of multipart compositions, the toccata is somewhat resemblant to the sonata, with the difference that there is generally a less definite number of parts and they are not separated like they are in the sonata. For example, in the standard form, an introduction may begin the piece, followed by an allegro which gives place to a slow passage ending in a final fugue. The toccata is mostly a baroque form of piece.

The Opera

From its beginnings at the time of baroque music in the seventeenth century, until the peak of its growth and metamorphosis in the nineteenth century, and even after, here is undoubtedly the drama stage of music, a titan and a colossus among musical forms. The term « opera » comes from the Italian, but it recalls the Latin word « opus, operis » which means « work », « creation ». The opera is probably the only musical form to unite all the arts : music of course, drama, painting and sculpture (for the background and the decors in general), literature – because opera calls for a libretto, a text on which to build the story, often in a poetic form – and cinema, for the visual, lightning effects, scenery... Maybe because it is an art form so complete, opera has probably made more polemics, wars, conflicts, and passionate critics than all the others in the history of music.

On the whole, it is very much like a play in a theatre, except that the text is sung, and the importance is given to the music before the words and, most of the time, before the plot. In Italian opera, the singers, who are like the actors in a play, have arias, passages which do not correspond to a progression in the action of the story, but enable them to make show of their virtuosity and the unique characteristics of their voice. The distinction between Italian, French, and German opera will be made more clearly in the next part of the present work. Sometimes also in certain operas, like the singspiel, the singers must pronounce the text in normal speech, without singing. The comparison just made of the opera with a play, induces that an opera is divided into acts and scenes, with either an overture opening the entire work, and occasionally an orchestral introduction before the last act, or a prelude before the first and the third acts.

 Even though it involves the accompaniment of an entire symphony orchestra, opera is principally a vocal work. Many other vocal works exist by various composers, among which, principally, sacred works like masses – a musical setting of the text of the mass –, requiems – the prayer for the dead – which are usually in Latin, cantatas, oratorios – an Italian style more closely related to opera – magnificats, and still others. Among non-sacred music, and on a smaller scale, can be mentioned the lied, in which some composers excelled, and which is a musical setting of a written form, generally a poem. The term « lied » means « song » in German. The lied is sung in solo, generally with a piano accompaniment.

THE HISTORY OF MUSIC

INTRODUCTION

Discovering gradually the world of music, the laws which rule over it and upon which it is constructed, the many forms it takes and the agents it engages, one necessarily assumes that such a complex and intricate framework should have an elaborate history to the measure of its greatness. And, indeed the history of music is long and fascinating. It will be briefly exposed in this third part through three principal ages which successively dawned upon music, and which are all distinct in their own right : the Baroque era, the Classical era, and the Romantic era. Before the Baroque era and after the Romantic era, and from the Baroque era to the Classical era and the Classical era to the Romantic era this faithful companion of man never remained dormant, and these times will also be mentioned. The actors are many – and the composers, critics, and even interpreters whose toil has left its legacy, all contributed to build and sustain this priceless and colossal repertoire. It may be that, following the thread of this journey, it become apparent that this extraordinary form of art, which is nowadays appreciated in spite of all the distinctions which divide it, has never ceased to modify itself according to the context and the political, moral, religious situation of mankind, reflecting the society which gave it birth ; but that this etheral, immaterial, ideal element be the source of so much conflict, passion, so many polemics and as much love and hatred as any political subject has ever been, this is what truly captivates anyone who endeavours to understand it.

THE BAROQUE ERA

Medieval and Renaissance times

 The beginning of this long history can be said to be religion, and its initiators, monks. And through the ages the supreme aim of music has ever been to exalt the glory of the Divinity. Even before the ornate and sophisticated Baroque style, which is generally considered its first flourishment, music existed already, since times as remote as Antiquity but more remarquably since the Middle Ages, when it became more than a simple entertainment. The Middle Ages are the remotest times to which written music can be traced back, the times of the minstrels who travelled through the world, entertaining the kings and the knights in their courts with their beautiful and melancholy songs, telling of strange stories and adventures. In fact, « serious » music, began its growth in the service of religion, for from these ancient times have survived almost only sacred works, secular music being improvised. Thus monks were some of the first composers in the history of Western music. Because of this preeminence of sacred music, the works which have survived from these times are mostly masses, motets and other religious forms. Some time later the secular domain also came to develop with the apparition of the ballade, the rondeau, the virelay... This period was made by names such as Hildegard of Bingen, Guillaume de Machaut, Palestrina, Lassus, and Thomas Tallis. Their works lead to the principle which would become the base of Renaissance music : polyphony. As its name indicates, polyphony is the presence of several voices in a piece, whose parts can be seen written individually on the score, each progressing according to its role, and rather independently of the others. This calls for several performers, establishing an already elaborate organization in the structure.
 And here in polyphony we have, so to speak, the foundation of counterpoint, and thus, of the Baroque style.

The first Baroque composers

The word comes from the Portuguese « barocco » which designates a deformed pearl. Although the sense was pejorative, it soon came to be used to refer to the complex, richly ornamental style of the era which followed Renaissance polyphony and its melancholy. The Baroque era can be said to have begun around 1600. The dawn of the golden age of the art of music, the first of the three eras which produced the most important musical repertoire in the history of the world, thus began. Composers who worked for the courts of the nobles and sovereigns of their time, and dominated the musical world of their country, be it Germany, France or Italy, had to take advantage of the incredible growth of both opera and instrumental music. Monteverdi in Italy composed some of the first and most successful operas : *L'Orfeo*, *L'Arianna*, *Il ritorno d'Ulisse in patria*, *L'incoronazione di Poppea*, as well as several madrigal series gathered together in collections. Schütz in Germany also wrote an opera, *Dafne*, and worked for several courts. But in France the musical scene was invaded and monopolized by one man : Jean-Baptiste Lully, who eclipsed all his rival contemporaries in greatness and fame such as few others have achieved. He was a terribly ambitious, opportunistic man, and his relentlessness in imposing his indisputable talent in the court of the greatest king of Europe, the Sun-King, has made his dazzling and superb music emblematic of its time. He collaborated with Molière, the great playwright of the King, and provided the accompaniment music for many of his most famous plays. However even during this growth of new and ever more varied forms, the importance of sacred music remained, and Schütz, for example, was prolific principally in religious works, Passions, oratorios and magnificats. Monteverdi also wrote religious music, motets and settings for voices and instruments of sacred pieces, and Lully, though a court composer mostly devoted to the King's entertainment, composed a Te Deum which was to celebrate the monarch's recovery from an illness. Lully's great English rival was Purcell, who was also his king's court composer, and whose music epitomizes the English style of the period.
 The Baroque era also saw the development of instrumental technique, which meant an increasing demand for virtuosic pieces whose

aim was to exploit the growing capacities of the perfected instruments and their ever more skilled players. Germany became a center for the development of the organ, exemplified by the works of Pachelbel, Buxtehude, and Italy always shone in the art of the violin, with Tartini and Corelli as some of its most excellent examples. In this respect Corelli was a master, and his considerable work of virtuoso pieces for the instrument, as well his concertos and other orchestral pieces, had a non-negligible influence on posterity.

The apogee

The year 1685 produced two musicians who were to become the greatest representatives of the Baroque era. All the generations to come, Classical and Romantic, considered themselves to be descendants of these composers, for they represented the transcendent reference in the history of music.

One of the two was Georg Friedrich Händel, whose career flourished in England where he was favoured by the void left by the death of the country's greatest composer until then, Henry Purcell. Although German by birth, a native of Saxony, Händel spent the most part of his composing career abroad, travelling to Italy – where the musical style in which he excelled, opera, was particularly favoured – and then England, where he stayed most of his life. In London he somewhat became the city's Italian opera composer, writing, under Queen Anne's and then George I's rulership, more than 14 operas, and numerous pieces for coronations and important events, such as the famous *Water Music* and *Music for the Royal Fireworks*. But perhaps more than his operas, the repertoire owes him his oratorios ; a genre to which he turned and which he finally adopted with even greater excellence than he had adopted opera. The oratorio allowed him to turn to Biblical stories and favour the orchestra and the chorus in comparison with the soloists, while maintaining the scenic presentation and a certain sense of unfoldment of a story, to which Händel was used as a former composer of opera. It is for these oratorios – among which *Israel in Egypt*, *Samson*, *Solomon*, and the

most famous, *Messiah* – the concerti grossi, the overtures, and other concertos, that he is mostly remembered and celebrated. Händel has left a priceless legacy to music, and his contribution to courtly and celebration repertoire, and to the development of the oratorio, is one history will forever treasure.

 The other of these two musicians was Johann Sebastian Bach, born in Thuringia approximately one month after Händel. Few of his contemporaries could have imagined that this man, who remained in his country all his life, was known as a simple church organist, and never attained great fame in the prestigious post of court composer, would yet surpass in posterity all the musicians of his time, even Händel, even Telemann, who was then the most appreciated and admired among his peers. His family was musical since generations, but it surely can be said to have reached its peak of excellence in the person of Johann Sebastian Bach. His beginnings as a violinist certainly inspired him for the creation of beautiful solo pieces and concertos for the instrument, while his later and most important post of organist made him one of the greatest, and perhaps the most genial, of all composers for the instrument. His sacred and secular works alike are masterpieces of their sort, and his productivity in either was determined, throughout his life, not by inspiration – for his seemed inexhaustible – but by necessity. Thus in the period when he worked in Weimar, for the Duke Wilhelm Ernst he produced many cantatas and other sacred works for the church ; in Cöthen then, he naturally turned to secular music as his patron, Prince Leopold, did not require much religious music : from this period come the six Brandenburg Concertos which are pieces of distraction (and occasional display of virtuosity for some instruments, like Mietke's newly-built harpsichord in the fifth concerto) ; and during his time in Leipzig he again turned to church music. Bach's influence had to wait the revival of his music in the nineteenth century to really bloom, and at his death he was far less known as a composer than Händel or Telemann. But from a modern point of view, more than 300 years after his death, his legacy to music is immense. He brought the cantata, the mass, the Passion to a degree even superior to that Schütz had attained a century before ; he developed the virtuosity of solo stringed instruments with sonatas and partitas for the cello and for the violin ; he exploited the association of a full orchestra and a solo instrument with violin and keyboard concertos ; with his collection *The Well-Tempered Clavier* – constituted of a series of Preludes and Fugues written in all the possible tonalities of the chromatic scale – he explored

in an almost daring freedom of tone, the capacities of the keyboard ; and finally his work *The Art of Fugue* experimented and genially developed his ever used counterpoint, bringing it with masterly talent to a visionary level. If to this we add the impressive amount of works for the organ which he naturally favoured as a professional organist, and still the orchestral suites a musician of his time was more than likely to compose, then this legacy seems almost unconceivable in its greatness, and it could truly be said to be one of the most colossal in the history of music. It has previously been stated that Bach's inspiration was almost inexhaustible as much for secular as for sacred music. And indeed, it was the same inspiration which produced the cantatas, the masses and the Passions, that produced the concertos, the suites and all the virtuosic, solo instrument pieces : that of a man whose rare vision of divinity and of the harmony omnipresent in nature, made every single piece of his vast work a praise of the greatness of the God he worshipped.

 To this duo a third musician can rightfully be added as one of the dominating figures of the Baroque era. He was born seven years before Händel and Bach, and while Händel was the voice of England and Bach of Germany, he was that of Italy. His name was Antonio Vivaldi, and he was born in Venice to a father who was already a fine violinist. This facilitated the way his natural talent would take : which would make him become one of the greatest composers and violinists of his time. His status of priest made it appropriate for him to write religious music, and history has left us a good deal of sacred vocal works such as the Gloria, Laudate pueri, Lauda Jerusalem, but his field of excellence was the violin, and the orchestra. His true place in music history, is as a composer of concertos whose Italian style influenced Bach and Händel. Indeed his perhaps best-loved and best-known work is the ensemble of four violin concertos, *The Four Seasons*, which depict with such genius the changing aspects of the four seasons. Thus was the Baroque era, which produced one of the greatest musical geniuses of all time, Bach, and upon the firm structure of which were built all the others.

THE CLASSICAL ERA

The Baroque heritage

In 1750 Bach died, and perhaps as an indication of his posthumous fame, though Händel lived for some nine more years, this is the event generally used to delimit the end of the Baroque period. The master of counterpoint had died, but still from him came the first representatives of the Classical period's advancements. He left to the world seventeen descendants, among whom three gifted musicians : his sons, who carried their father's illustrious name through the first Classical generation. Wilhelm Friedemann, Bach's first son, remained more or less in his father's Baroque tradition. Carl Philipp Emmanuel, Bach's second son, made the link between the declining Baroque and the dawning Classical ages, and so did Johann Christian, Bach's last son, known as « the London Bach ». The Classical era was one of light and simplicity, after the elaborate and sophisticated ornamental style of the Baroque movement. Classical music tends to free itself from the dramatic profusion of the Baroque which inherited some of the complexity of medieval and Renaissance polyphony. This is the time of the Enlightenment, with its new ideas on the supremacy of reason and knowledge over predjudice, the thirst for intellectual entertainment ; the time of the philosophers, Voltaire, Rousseau, Montesquieu, of the great satiric plays of Beaumarchais ; the time, finally, which is still considered today as the golden age of music. This first part of the Classical era lead by Bach's sons saw the appearance of some new musical forms. Carl Philipp Emmanuel Bach excelled in a genre which was to forebode a very important structure in later orchestral forms : this genre, in which he exploited several instruments such as the flute and the keyboard, was the sonata, and the structure it announced, was precisely the sonata form which was exposed in the second part of the present work, and which was thoroughly used not only in the sonatas but above all in the symphonies, a form in full flourishment at the time. The piano concerto had a remarquable growth with the works of Carl Philipp

Emmanuel's younger brother Johann Christian Bach, who also wrote a fine amount of operas as his career demanded.

The great Classical composers

In spite of this considerable influence extended by Bach's sons through their compositions, their contribution to music history was even greater for the future geniuses they taught. These included one of the first truly Classical composers to have been widely known and remembered through the centuries until present times : Franz Joseph Haydn, whose 104 symphonies brought the genre to a peak and established it as a dominant form which was soon to replace the suites, so favoured in the Baroque era. By this time the orchestra was already beginning to change. Importance was given to the brass and woodwind sections, and percussions became commonly used, while the Baroque orchestra was mainly constituted of strings. The emergence of the form of the symphony reflects these changes. No longer simply an ensemble of instruments united to interpret the different voices in the pieces played, the orchestra was beginning to appear as a coordinated, synchronized body in the need of being emphasized. The symphony filled this role. With a conductor to ensure the unity of the whole, a score for each instrument from the strings to the winds and even the percussions, and concert halls always more vast and suited to bring out the sound, Classical symphonies seem to be the first works to exploit all the scope and significance of a whole orchestra. But Haydn was not content with adding to the repertoire his 104 symphonies. From the teachings of Carl Philipp Emmanuel Bach he developed his own sonatas, string quartets and concertos. His output is one of the most significant of his era, and there is an originality and cheerfulness in his style which tell us more clearly than words of his jovial, energetic nature. He represents the end of a long period in the conditions of life of the composers. Music at the time was still reserved, like in the Baroque era, for the wealthy and the nobles who provided the post and the income for the musicians who were, in a manner of speaking, their personal composers. Thus we find Haydn working in Vienna for the aristocratic family of the Esterházys, employed successively by Prince

Paul Anton Esterházy, then Prince Nikolaus, and then Nikolaus II. This dependance to a patron was desirable for composers of the time, in a way because it secured their employment and income, but it was also felt, for free and original spirits like Haydn, as a restriction to a more worldly and wandering way of life. First, the loyalty to a wealthy patron limited the possibility of travelling, as the composer was attached to a court and most likely resided near his employer. Then also, working for a single patron meant that the composer must adapt his inspiration to the demand of the patron. When he worked for Nikolaus II Haydn wrote almost solely sacred music, producing his greatest and most numerous masses under the patronage of this more austere prince. He was one of the last of the great composers to be employed in this way, and probably the first of the truly great and well-known Classical composers. His legacy resides assuredly in his colossal series of symphonies, but also in his concertos, string quartets – among which the famous « Emperor » – and sonatas. He also produced some oratorios in the style of Händel, The Creation and The Seasons, but his most significant contribution was probably that to the development of the sonata form and of course, the Classical symphony, by means of which he admirably paved the way for his illustrious successors.

While Haydn was attaining the height of his fame, more and more changes took place in the musical world. Music was becoming emancipated from the privileges of the nobles, and an emerging middle-class began claiming its rights to demand its own musical entertainments. Music became accessible to the general public, and as on the grand scale concert halls were multiplying and their structure improving, smaller groups were also increasingly common for the private enjoyment of music. Both undergoing and promoting this context, was born on the 27th of January of the year 1756 in Salzburg, certainly the greatest musical genius humanity has known : Wolfgang Amadeus Mozart. For the scholar and the layman alike Mozart epitomizes the spirit of Classical music, the term « Classical » being taken not only in the particular but also in the general sense. Despite Salieri, Paisiello, despite Bach's sons and Clementi, Boccherini, more famous or appreciated as teachers, despite even Haydn whose work has largely survived compared to that of the others, the name of Mozart now dominates the golden age of music with unrivalled absoluteness. The Classical era was already well started, and Mozart was neither its initiator nor the instigator of its termination. One wonders, then, why he remains surrounded by such an aura of universal fame. The reason perhaps resides in this very particularity, and this is

what made him so exceptional. Without having an intention of changing the course of the Classical style or starting a new movement, Mozart has produced a work which must be considered the greatest of all the repertoire, a work whose originality and freedom of construction points despite itself towards all the future changes more than two following centuries of music would undergo – an originality and freedom manifested not only in his compositions but also in his career. He was indeed among the first of his contemporaries to be, in a manner of speaking, self-employed, and never under the patronage of a wealthy protector powerful enough to guarantee the security of his situation.

Mozart excelled in every genre and his works in all musical forms are masterpieces of their kind. In the domain of the symphony he has left us more than fifty works which must be regarded as innovative, if not in structure, at least for their highly original language and dramatic tones which more than once must have surprised audiences of the time ; in that of the concerto in general and the piano concerto above all, his legacy is even greater, covering nearly all the instruments of the orchestra, exploited in these works with both virtuosity and true feeling, especially the piano ; in that of chamber music the repertoire owes him some of its best-loved and best-known works, works for solo instruments like piano sonatas, and for small ensembles like quartets, divertimentos, serenades ; and the sacred repertoire counts among its most magnificent pieces, his masses, Solemn Vespers and his sumptuous Requiem, probably the most appreciated of its kind. But surely Mozart's true passion was for the genre which represented the most for a composer, a genre which was already blooming at the time and whose growth ever continued in the centuries which would follow : opera. It is certainly his operatic melodies which remain among Mozart's favourites in present times. His few twenty operas are full of the inspiration and spontaneity of his genius, and the most celebrated, *Die Zauberflöte, Don Giovanni, Le Nozze di Figaro, La Clemenza di Tito, Cosi fan tutte*, are frequently heard today and represent Classical opera in all its purity. Mozart took his libretti from both German and Italian texts, setting them to a music of striking originality and freedom of spirit which make them unique ; they do not belong to a style, they are a style by themselves. But while *Cosi fan tutte, Le Nozze di Figaro, Die Entführung aus dem Serail* are all comic operas, there is a gravity and dramatic depth in *Don Giovanni*, and a mystic atmosphere and symbolism in *Die Zauberflöte*, which distinguish them from the rest, and are felt in their profound, dark overtures. *Die Zauberflöte* is full of secret

masonic codes and allusions, the composer having been, most of his life, an enthusiastic freemason.

Opera had its own history even in the Classical era. Mozart had more than one rival. The Italians, among whom were Paisiello and Salieri, were more famous in their time even though many were still jealous of Mozart's evident genius, and from Germany, nearly two generations before Mozart, came another opera composer : Christoph Willibald Gluck. He set his music to French and Italian texts, but he was the first to begin the change which would continue throughout the Classical and Romantic eras in the never-ending reforms of the opera. Until then operas had been using mythological and epic themes and tragic stories for their plots, much like the authors Racine and Corneille wrote tragedies and staged heroic figures as their characters for their plays. But just as in literature comedy began superseding the more austere tragedy, so in music composers like Gluck sought to satisfy the audience's growing demand for entertainment, and began replacing the « serious » opera based on the epic scenes of Antiquity, by a more realistic, topical type of opera which presented everyday life scenes and subjects. Although the titles of his operas suggest the opposite, with names such as *Orfeo ed Euridice, Paride ed Elena, Echo et Narcisse,* he was neverless one of the first to free opera from its dependance and submission to the famous singers of the day – who mostly regarded it as a means of making show of their vocal feats – , and the initiator of this new type of work, in collaboration with his librettist, Raniero de Calzabigi.

The dawn of a new era

While Vienna flourished as the center of all the renowned musicians of Europe, while Haydn and Mozart, Salieri, Paisiello and Boccherini were following their respective careers, another life was blooming in Germany, in Bonn, a life which, beginning in the Classical era, would forever change the course of music. Ludwig van Beethoven was born in 1770, at a time when music was becoming involved with the war which seized Europe. Significantly enough his music retained the atmosphere in

which it was born, and which seemed to imprint on it a nature of revolt, of fieriness, and of aspiration far beyond the common aim and principles of the Classical era. In the domain of Classical music Beethoven has left us many fine works, which mostly belong to the first part of his creative output. These can be considered as Classical in the sense that they belong, at least in structure, to the style in which wrote Haydn and Mozart, although they already bear the stamp of a rebellious, unconventional character. The emperor, Joseph II, himself declared : « there is something revolutionary about that music ». In this class can be counted at least the first two symphonies, the first two piano concertos, some of the first piano sonatas and chamber music for various instruments.

In his first years Beethoven, after having had his harsh father as his first teacher, and having been instructed a while by Christian Neefe, the court organist – an experience maybe at the source of his admiration for the organ – he was able to leave Germany for Vienna to study under Haydn. But already the fiery and rebellious initiator of the new era was at odds with the first master of Classicism, original and unconventional though he be. For it was not for Viennese Classicism that Beethoven would give his greatest gift ; but for the next age which was already dawning.

THE ROMANTIC ERA

The revolution

On the 7th of April of the year 1805 Beethoven's symphony no 3 nicknamed « Eroica » was premièred in Vienna. This event was to change the history of music forever. It also marked a change in the history of art in general. It is significant that while the transition from the Baroque to the Classical eras seems to have taken place relatively peacefully and

progressively, the same could not be said of the passage from Classicism to Romanticism. This was a time of conflict and turmoil for Europe, the time of Napoleon Bonaparte's conquests and of the lightning succession of governments which rose and fell during his gains and losses of power. Perhaps Beethoven's revolution in music mirrored Napoleon's revolution when he undertook the conquest of Europe.

In his lifestyle Beethoven certainly seemed more conventional than Mozart to his contemporaries, and from this point of view he seemed to belong more evidently to the Classical era than Mozart did. Indeed, like Haydn, Beethoven benefited from the support of wealthy patrons who ensured a minimal financial security for his needs during most of his life. But it was his music, its character and its scope, which foreshadowed a new era in the history of art, an era whose initiators were determined to reverse everything and every law which had been at the base of Classical principles. This revolutionary style defined itself through two principal pecularities. Firstly, it was a music of new extremes and tremendous emotional power, which did not concern itself with reason and lightness anymore, but the expression of all possible human emotions and the fantasies of the imagination, and used every conceivable means to emphasize them. While the beauty of Classical works rested on the balance of proportions and the harmony of tones, on the contrary Romantic works based their efficiency on disproportion, occasional discords – not that they were not present in Baroque and Classical works, but their use was different – and contrasts which precisely allowed the expression of emotions. Romantic music sought to draw nearer to nature, and while Classical pieces seem to praise the mastery of man over nature, Romantic works try to express the power of the forces of nature and their similarity with the human heart in which they stir deep feelings.

Secondly, the characteristic of Romantic music, was its interest and involvement in contemporary politics and the world in the midst of which it was created. Similarly Romantic artists like Beethoven became deeply concerned with the succession of governments, rulers and revolutions which rose and fell during the period when he composed. Music became a means of paying homage to solemn events or monarchs of the day, and its new energy and passion served the purpose of dramatization it had acquired for ceremonious occasions. This connection of the arts to the contemporary political events also brings forth another characteristic of Romanticism : its connection with, and research of, the other art forms and especially literature. Novels, poems or plays by Romantic authors became

the inspiration for many musical works, a collaboration which seemed to point the way for one of the most important attempts of the 19th century which will be exposed more clearly at a later point : a desire to achieve a union of all the arts, that they may create a complete and perfect work of art, including literature, drama, the visual arts and of course, music, which was to play a prominent part in this union.

As well as promoting these changes, Beethoven also made structural improvements to music, improving the sonata form in his symphonies and piano sonatas and giving orchestral music a scope and scale never achieved before. He also contributed to some extent to the opera repertoire with his only work in the genre, *Fidelio*, although it is rarely heard today. Once more this was a work directly linked to the political events of the day, with a plot involving a prisoner whose wife attempts to release him. Beethoven was even forced to transfer the story in the setting of the Spain of the eighteenth century, so mingled with the French Revolution was the action. The representation of the opera was not successful, but Beethoven's only work in the genre remains appreciated as do his few sacred works, among which his great Missa Solemnis stands as a masterpiece in the universal sacred repertoire.

Like Classical composers before him, Beethoven wrote in all principal genres and left masterpieces in almost every form, but the more limited number of his symphonies and concertos – nine symphonies, five piano concertos and one violin concerto compared with nearly fifty symphonies, thirty piano concertos, five violin concertos in addition to several wind concertos for Mozart – announced the new era : a slower manner of composing, generally longer pieces, and an inspiration which, being dictated by the rhythm of Nature and the course of the emotions, was subject to peaks and voids. And hearing the finale from the fifth symphony or the *Ode to Joy* from the great ninth, one indeed feels an embrace for all humankind ; the beginning of a movement which, after the fall from the golden age, attempted a last reach towards the sky.

Next to this giant of the pre-Romantic era, a composer more modest in the scale of his works and ambitions, but certainly not in the significance of his genial and abundant productions, remains to be mentioned. Born 27 years after Beethoven and buried just one year after the death of the elder master, this son of a Viennese school instructor never saw his works performed professionally, and always played his piano pieces in small salons among friends, and yet his remarkable amount of songs, piano sonatas, impromptus, waltzes and his nine

symphonies all bear the stamp of a spontaneity in the inspiration and a prodigious melodic gift, which can only be attributed to the pen of a genius. This man was Franz Schubert, whose unique style fills the gap between the Classical and Romantic eras while being attributed, according to the opinions, to both. His works, imbued with the influence of Beethoven – whom he deeply admired – especially the symphonies, of which, like Beethoven's, there are nine, his works are neverless highly original and manifest a spontaneity, a lightness and a melodic ease, which are a trademark of his genius. Moreover, he can be considered an innovator in the form of the lied, of which he wrote an important amount divided into several collections. The lied was a form well-suited to and typical of the Romantic ideology, being the musical setting of a literary work, often a poem, arranged most frequently for voice and piano. The text is sung to the accompaniment of the piano. Among the writings chosen by Schubert as base for his lieder (which means « songs » in German) are many poems by the great master Romantic writer and poet Johann Wolfgang von Goethe, and thus not only were the pieces of Romantic inspiration, they exemplified the link between literature and music, which was characteristic of the Romantic era.

 Schubert also began and epitomized another side of Romanticism, which seemed to contradict the expansion of the orchestra and of grand scale music : the apparition of small scale music, short or intimate pieces intended to be played on one instrument, like the piano, and in small salons and for limited audiences. Thus began the « Schubertiades », the soirees Schubert held with his friends, and during which he introduced and played his numerous piano pieces, outside of public performances. These pieces, impromptus, valses and moments musicaux for the most, were intended for the delight of his close friends and not for the success of the concert hall. He thus began a line of pianists and chamber composers who were to define this genre in the latter part of the Romantic era. His illustrious predecessor had engendered a noble lineage of followers who were to light the future era with a genius that was a tribute to his greatness.

The War of the Romantics

The preparation had been made for one of the greatest battles in the history of art. From this moment on the history of music becomes complicated and agitated. The term « war » used in the context of an artistic current means the same it always does : that of a split between two forces, and to understand what these two forces are, it is necessary to follow the succession of events which made one of the most, if not the most famous artistic revolution in the history, not only of music, but of all the arts. On the 18th of June of 1821 Carl Maria von Weber's *Der Freischütz* was premiered in Berlin. The opera, with its theme of conflict and the powerful opposition between the forces of light and those of darkness evoked in its sumptuous overture, foreshadowed the real conflict which was to come ; the beginning of an era of change and separation, of polemics and of passionate strifes without equivalent in the Renaissance, Baroque or Classical eras. The War of the Romantics did not confine itself to the world of music. In France, writers like Alphonse de Lamartine, François-René de Châteaubriand, Victor Hugo, took the head of the Romantic movement in literature. The main chosen field for the polemic was the theatre : Romantic plays like *Ernani* or *Lorenzaccio* became the means of expression for the avant-garde writers to revolutionize everything from the bourgeois comedy to the Classical tragedy, blending them in a sort of new style which came to be called the Romantic drama. And thus in music also was the paradox of Romanticism : it divided and separated, when it wanted to blend and unite.

Not surprisingly, this mostly began with opera. After Gluck had brought his changes, and Mozart's operas had competed with Salieri's and Paisiello's, the Italians took the genre of the opera buffa and made it their specialty after Mozart's death. Italian opera and its bel canto style, in which emphasis was made on the beauty and length of the melodies in the arias of the singers, came to influence an entire line of musicians, pianists or mostly « orchestral » composers. Donizetti, Bellini and a composer named Gioacchino Rossini, took almost entirely possession of operatic music and if, nowadays his works are certainly the most remembered among those of the three, in his time his fame was unparalleled. His

incredible capacity for composing quickly and his entertaining and realistic characters made him the idol of the public. His operas are still favourites in present times, particularly *The Barber of Seville* and *Guillaume Tell*, his last. *L'Italiana in Algieri*, *La Cenerentola*, *Semiramide* are also still frequently performed. Rossini brought some innovations to the opera repertoire, notably the orchestral passages instead of the keyboard-accompanied recitative, and the expansion of the chorus. The further development of the opera buffa was based on his works, and he developed the coloratura aria. Opera had been taken completely : the name of Rossini was in every mouth, the very synonym, for a time, of the name of opera.

In the midst of this frenzy, Weber had some difficulty to emerge. Notwithstanding his frail appearance and delicate health, this relative of Mozart's wife Constanze Weber, soon began rising against the success of Italian opera, a new German opera. The German school distinguished itself from its rivals by several characteristics, among which can be cited the increasing of the importance of the orchestra, and the preeminence given to the plot and the characters, in comparison with the arias of the singers and the décor – even though *Der Freischütz* was so successful partly because of its spectacular décor and costumes. Weber had to face two fearsome rivals : Rossini, who had become by now the sole idol of the public, the leader of Italian opera, and Meyerbeer, the dominating figure of French opera with his masterpieces, *Les Huguenots*, *Robert le Diable*... The distinctive characteristics of each style are more or less marked, but on the whole, Italian opera concentrated on the vocal feats of the singers, by giving them long and complex melodies to show off their virtuosity, and thus Italian arias are the most known and famous in the opera repertoire ; while French opera put an emphasis on the décor, enhancing the drama and atmosphere of the scenes with elaborate scenery. The new German opera launched by Weber became more dramatic, profound and concerned with mysticism and symbolism. With *Der Freischütz* the new style achieved its first triumph. Based on the national folklore, the story was perfectly well-suited to the mysterious and deeply contrasted music which evoked more than ever the fight between light and darkness. Weber's subsequent operas, including *Oberon* and *Euryanthe*, were less successful, but the magnificent overtures all announced , with their dramatic tones and bold spirit, the era of conflict which was beginning with the new school.

Meanwhile parallel Romantic styles were developing aside from

opera. Niccolo Paganini, the great Italian virtuoso violinist, while continuing the tradition of his ancient Baroque countrymen Tartini and Corelli, launched with his unprecedented virtuosity, what was to become a typical Romantic image : that of the virtuoso performer. His fantastic, almost surreal mastery of his instrument dazzled and mystified audiences – thus creating the legend of the « mad genius » – and made countless imitators, among other violinists in the nineteenth century, like Sarasate, Vieuxtemps, but also among virtuosos of other instruments. Franz Liszt, the Hungarian pianist, whose active part in the War of the Romantics will be mentioned further, composed most of his virtuoso showpieces – among which his Etudes d'exécution transcendante and his Grandes études de Paganini – under the inspiration of Paganini's incredible technique. His celebrated piano piece *La Campanella* is directly constructed on the theme of the concluding movement from one of Paganini's violin concertos, precisely bearing the name *La Campanella*. Liszt wanted to prove that he could with the piano display as many extraordinary feats of virtuosity as Paganini could on the violin. Thus was born a new concept which placed the instrument at the center of the composer's interest as an aim in itself : instead of the instrument serving as an interpreter of the music, it was the music which was composed for the instrument to highlight its tone, qualities and almost as importantly of course, the virtuosic capacity of its player.

This movement was at the origin of another style which developed in response to this frenzy for virtuosity and public demonstration. A new genre of chamber music blossomed in the salons of the wealthy, mostly for the piano. It was a more intimate sort of music, with short pieces destined to entertain and embellish the soirées in the aristocratic salons. This was the genre which Schubert's works had earlier foreshadowed. In the 1830s a Polish-born composer arrived in Paris. His name was Frédéric Chopin, and amidst this aristocratic society, in the city of literature, of all the most distinguished writers and artists of Europe, he became known as the poet of the piano, the refined pianist whose unprecedented delicacy of touch and soft playing suited well the Parisian salons and contrasted with this current of virtuosic show. Chopin's intimate pieces, Nocturnes, Valses, Berceuses and Ballades bore a typical melancholy and refinement which evoked Parisian salons, while his more passionate Polonaises and fiery Mazurkas expressed better than any composer's music before him, the sadness and suffering over Poland's tragic fate. Still in another side of his inspiration his Preludes clearly show the influence of Bach whom the

magnificent example of Baroque order and regularity associated with Romantic mystery and dramatism, together with enigmatic melodies only Chopin could think of. Frédéric Chopin was a unique figure in the history of Romanticism, and though he seldom appeared in public during his life his influence on his contemporaries and successors, if not always apparent, was immense. And at the end of his short life he would ever be remembered for the image he left : that of a man who prefered the company of the wealthy and noble to that of his fellow musicians, the aristocratic salons to the concert hall, and the music of Bach and Mozart to all the Romantic novelties of his era.

But once more it was opera which had been chosen as the battlefield for the great War of the Romantics, and to it we must return. In this beginning of the nineteenth century after the death of Carl Maria von Weber, a new German avant-garde school emerged, the members of which called themselves the Radicals. At their head, Richard Wagner, an admirer of Weber and rightly his successor. Wagner believed that progress in music and in all the arts rested on new forms, and opera before any other art form. He certainly began rising in the shadow of his main inspiration, Weber, but his fight was bitter and his conquest of the musical world, lightning. His ideas on the archaism of the symphony inspired his followers to create new art forms if they had no particular interest for opera. Thus in the development of the Romantic movement we see the apparition of the symphonic poem, an orchestral one-movement piece, often descriptive of a literary work at the base of its inspiration. But Wagner's hope, for the time being, rested solely on opera. His lifelong thrive, and an idea which was to dominate more and more his artistic endeavour, was to achieve through opera a union of all the arts, and indeed this was a well-chosen path. Never before had any other art form necessitated the collaboration of so many fields : literature for the libretti, the texts, often in verse, on which the musical lines were composed, and which constituted the opera's plot ; the visual arts, painting, sculpture and architecture, for the décor ; theatrical and scenic arts, because an opera is like a play on music ; and mainly, of course, music itself, which was the dominating collaborator. This idea, again, well belonged in the Romantic spirit, as the elaboration of the libretti demanded the collaboration of writers and poets, like Goethe in the case of Gounod's *Faust*, or writers who created a text on demand, just for the opera. But Wagner was an exceptional character, and the scope of his artistic vision reached far beyond this Romantic ideology. Unafraid, as he always was, to surprise

and inflame the opinions, he decided that the composer, to be entirely free and independent in his work, must write the libretti himself, without the collaboration of a writer. He thus was the first opera composer to systematically create his work entirely. This was a colossal achievement, but Wagner's energy was at the measure of his single-minded ambition, and he became the composer, the writer and the poet for his operas, while having to cope with both the opposition of the Conservatists, and the rivalry of the Italian and French operas, of which Offenbach with *Orpheus in the Underworld*, *The Tales of Hoffmann*, and Bizet with *Carmen*, *L'Arlésienne*, were the champions. Meanwhile the scission was intensifying between the two parties of the Romantic war. As Wagner was developing his theories on the unification of all the arts, valuable members were joining either one of the two sides. Although they were not yet really opposed before the second half of the 19th century – Rossini received in his Paris estate, many young avant-garde musicians who admired him, among whom Wagner – tendencies were already developing and the way was preparing for the great division. On the Conservatist side were, of course, Rossini, the king of Italian opera, Meyerbeer, Mendelssohn – although not openly hostile to the new German school he was on the whole indifferent to its ideas, and his music, with its charm and balance, is more Classical than Romantic in spirit – and the music critic Eduard Hanslick, whose pen was fearsome to his enemies, and who became dedicated to the Conservatists. On the radical side, this is to say on Wagner's side, were the virtuoso pianist Franz Liszt, who was mentioned earlier, and in a certain way, the French composer Hector Berlioz, whose relation to Wagner was friendly. The two musicians, Berlioz and Wagner, shared several views and were on the whole in agreement, but Berlioz never belonged to, or formed, a class. His tormented, passionate music and his obsessive and impulsive nature made him an embodiment of the Romantic artist ; and his highly original works, among which the Symphonie Fantastique, which is more of a symphonic suite than a symphony, show a style which inspired many composers of his early and later contemporaries without ever forming a school. It can be said of Berlioz that he was born before his time, and that his music became truly appreciated only after he had passed through the same trial as the hero of his Symphony Fantastique – death. As for Franz Liszt, he naturally entered on Wagner's side not only as the chief promoter of his works, but also as a true innovator in his own productions, virtuosic piano pieces and orchestral pieces. They exploit the same harmonic innovations

as some of Wagner's later operas, and his use of the chromatic scale reaches to the limits of tonality. He also more or less belonged to a group of rising nationalism in music, with composers expressing in their works, the love of their homeland. Thus Norwegian composer Edvard Grieg, with his piano and orchestral pieces, his great piano concerto, his suites for the play Peer Gynt and even his suites in the ancient style, evokes the atmosphere of his native land, as do Czech composer Bedřich Smetana's works. Liszt's Hungarian Rhapsodies are intended to evoke the composer's native Hungary, although Liszt himself was never really informed enough about the culture, language and people of his native Hungary, to avoid confusions in the Rhapsodies' evocations. More importantly, he was a powerful champion, and his charismatic stage presence and success with the audience, allowed daring works by avant-garde composers, to be accepted and appreciated when premiered under his baton. Liszt always took advantage of the adulation of the public, and on the whole his output is maybe richer in transcriptions of pieces by other composers (for example, piano arrangements of Beethoven's symphonies, Schubert's lieder or operatic passages) than of his own works. These bear a unique sense of grandeur, a force of light, of pride and of greatness, which are a trademark of his visionary style and tell of high and majestic worlds, where glory and virtuosity manifest themselves through the strangest tones and harmonies.

In 1842 Wagner won his first victory with *Rienzi*, a Parisian opera which he himself despised. Based on a novel by Edward Bulwer-Lytton, its concern with politics – the tale is about a Roman tribune – made it a dangerous stake for sanctions, and the first reaction to an article Wagner had written on monarchy, was *Rienzi*'s removal from the program of the opera. But *Rienzi*'s magnificent overture and Classical arias were not at the height of Wagner's ideal ; another type of opera must be created, of which *Die Fliegende Holländer*, The Flying Dutchman, based on the legend, was the first real attempt. In it the arias of the singers have almost all been suppressed in favour of a system which, according to Wagner, allowed a more profound and perfect fusion of text and music. In fact, the role of the singers and that of the orchestra have, so to speak, been interverted : instead of singing arias especially made for them, the singers use a sort of phrasing to accompany the orchestra which plays the themes of the opera and carries on the melodic line of the story. Wagner came to call these operas « music dramas », of which *Die Fliegende Holländer* was the first achieved example. This brings us to mention one of

Wagner's innovations in the operatic field : the improvement of the technique of the *leitmotiv*, already used in earlier operas but considerably deepened in all of his later works. The *leitmotiv* in music is a theme, a melody, which is associated through the entire work to a character in the story, a place, or an idea, like love, forgiveness, victory, or redemption. The apparition of the theme announces that of the element it refers to, or the relation of the element to the events which take place, and the theme may undergo transformations according to the evolution of the element in the story.

In 1868 with Rossini's death, and Liszt still at his side, Wagner progressed in his advance and discoveries, ever modifying his works depending on the evolution of his ideas, ever approved by his fervent admirers – who rarely understood the depth of his ideal – ever recused by his detractors. By then he had acquired a new and powerful protector, King Ludwig II of Bavaria, who, out of sheer admiration for his transcendant genius, had paid all his debts and given him an estate, which favour put a temporary end to his constant flees, from scandal and from creditors, and exiles. But he also had to cope with the apparition on the scene of probably the greatest rival of his career. In 1853, a twenty years old young man came, from the city of Hamburg, to be enthusiastically received by the composer Robert Schumann and his wife Clara. His name was Johannes Brahms. Deeply impressed by his talent, Scumann had predicted he was the new successor and true heir of Beethoven who would restore the tradition of the past and of Classicism and rise against what he already was beginning to consider as a false school of the future. Perhaps he had foreseen the coming of the climax of the conflict, in this young man who, careful and reserved, made his entrance on the scene in the midst of the battle. This paid him hard : on his arrival he was cruelly attacked by Wagner in a skillful article, On Conducting. This difficult beginning already installed the base of his hate for the radical school, and encouraged him to reaffirm the mission Schumann had bestowed upon him. Brahms infused the Conservatists with a new life and a new hope, and by the beginning of the latter part of the nineteenth century the musical world was divided as never before. Brahms' arrival marked the real beginning of the War of the Romantics. The Radicals had chosen Weimar as the center of their movement, while the Conservatists were installed in Leipzig, the city in which Bach, Mendelssohn, Schumann had lived, and which became their headquarters. On his side, Brahms benefitted from the powerful support of the music critic Eduard Hanslick

who had joined the cause of the Conservatists and was a mighty ally, the violinist Joseph Joachim who was also a close friend, and Schumann's widow, Clara, who retained a lifelong affection for the musician Schumann had loved as a son during his life, an affection which intensified after her husband's death. The opposition became violent. Conservatists refused to attend concerts in which were presented works with Radical tendencies, performances were sabotaged, and adversaries fought as much with the pen as with the music. Articles were written on either side. The artist who dared to criticize a work of a member of the rival movement was sure to be attacked by the rivals at the first occasion. Significantly enough, Brahms was as different from Wagner as the Conservatist movement was different from the avant-garde movement. A careful and modest man, he often feared that his works were not at the height of the hopes Schumann had placed in him, and destroyed dozens of compositions which he judged unworthy of Beethoven's genius. For both sides of the Romantics pretended to be continuing Beethoven's revolutions and improvements, and Brahms' symphony no 1, which it took the composer more than twenty years to compose, so obsessive was the care with which he revised it again and again so as to perfect it to his ideal's image, was meant to be « Beethoven's tenth ».

In the late nineteenth century Wagner began creating his most ambitious work, the great *Ring* cycle of operas. This colossal masterpiece, a Titan even on the wagnerian scale, was a tetralogy constituted of four operas, *Das Rheingold* (the Gold of the river Rhine), *Die Walküre* (the Valkyrie), *Siegfried*, and *Die Götterdammerung* (the Twilight of the Gods). Based on the myth of Siegfried, a hero of Germanic mythology, the work took several days to be represented in its entirety, and the performances were long and expensive. By 1876 Wagner had built an opera house in Bayreuth, especially meant for the representation of the *Ring*. His ideas on the true nature and aim of the musical drama, were still more precise than before, and one of his last works, *Tristan und Isolde*, is now considered to be the closest to his theoretical ideal.

But at this time he had been on disagreement with Liszt and a new class of followers appeared. Paradoxally, this class seems to have been a new wave of symphonists in the tradition of Beethoven. Anton Bruckner, who discovered Wagner through a performance of *Lohengrin* and met the composer in 1864, composed nine symphonies which use certain wagnerian themes and harmonies, but bear their own original style, with long melodies and limited thematic development, and characteristic,

sudden silences which also remind his sacred organ works. Bruckner was firstly a religious composer, whose intense faith is well expressed by his profound, deeply devotional music.

Another late Austrian symphonist, often associated with Bruckner while very different in every respect, was Gustav Mahler. Widely known as a conductor, Mahler has nonetheless composed ten great symphonies, of which the eighth, the *Symphony of a Thousand*, (thus nicknamed due to the impressive number of its executants during its first performance) is one of the most renowned. Mahler's symphonies are the link between the great Romantics and the music of the twentieth century, and his legacy is one of the last of Romanticism. A third successor to Wagner and one of his closest followers, was Hugo Wolf, an exact contemporary of Mahler, but a very different character. Contrarily to Mahler, who expressed his ideal in great symphonies and orchestral works, Wolf found in the lied a form which suited well the scale of his inspiration and allowed him to establish his style without having to manage a whole orchestra. He considerably expanded and improved the form since Schubert first began using it, and although his difficult, moody nature isolated him from his fellow musicians and contemporaries his many fine songs are not lost and represent a considerable asset in the repertoire of the lied.

Throughout the Romantic era opera was dominated by two great figures. Wagner had only one rival : Giuseppe Verdi, born on the same year of 1813. Had Wagner been the only great opera composer of the nineteenth century, Italian opera would certainly have been forgotten after the apogee of Rossini's success. But Verdi arrived from his little village of Busseto at a time when Germany was beginning to take over the world of opera. Quietly making a name for himself with his innate sense of melody and drama, he used during his life, some of Wagner's innovations, including the continuity of the melodic line, a dangerous step at the time, which cost him to be regarded as an imitator of the great avant-garde leader. But his approach to drama and the characters was fundamentally different ; instead of focusing on symbolism and creating allegoric characters, Verdi was interested in historic characters and consequently chose, rather than mythology, history as a theme for his operas. One of his first truly famous operas, *Nabucco*, gave him the success he needed to conquer the public ; but his later works, *Attila, Ernani, Macbeth, Rigoletto, Aïda, La Traviata*, developed a style which became unique and typical of Verdi : a reduction of the importance of the arias of the singers – which was so valued in the tradition of the bel canto style – in favour of

the orchestra and the dramatic atmosphere. Verdi was one of the greatest melodists in the history of composition, and his arias are among the most beloved of the repertoire. His characters reveal a talent for dramatism and a deep psychological insight. His style mingles dramatic intensity with a strange fantasy and poetry to which only his rich imagination and spontaneous genius, are the key.

Post-Romanticism

After Wagner, Romanticism seems to have taken two separate though simultaneous ways. Some last great post-Romantic composers like Richard Srauss carried on the creation of great operas in a style which could be called wagnerian to some extent, and hearing Strauss's *Der Rosenkavalier* one feels Romantic opera attempts a last reach towards the ideal of the nineteenth century, before atonality and serial music took its place in the domain which had until then been its own. As for Italian opera, it found Verdi's successor in Giacomo Puccini whose operas, *Tosca, La Bohème, Madama Butterfly*, are still favourites in present times.

The first of these two currents mentioned higher, is that of atonal music. Until then composition had always been restrained by the rules of the tonal scales, which are arranged in a definite order, outwardly shown by the disposition of the white and black keys of the piano keyboard. With atonal music composers sought to make use of the chromatic scale, which meant that the scale which they employed was no longer subject to this division, but constituted of all the half-tones which equally separate the notes of any scale. Atonal music conveys a disturbing feeling of insecurity and uncertainty, and allowed in this period, as well as a greater freedom of creation, an expression of the anguish and distress caused by the coming of the century and the two consecutive world wars. Works by French composers like Claude Debussy, Maurice Ravel, which exemplify a musical Impressionism, stand at the cusp between late Romanticism and twentieth century Modernism. This era also saw the emergence of American composers who used some of these innovations. While Aaron Copland attempted a merging of American folk and jazz music in his own style to create a typical American art, Samuel Barber would not let go of

the late Romantic tradition of the end of the past century, and most of his works are written in the traditional forms. Among his best-loved works is the adagio for strings, which can be considered one of the most elegiac pieces of music ever composed.

Concurrently, another type of music appeared, which was the result of a different kind of quest for creative freedom on the part of composers. Many musicians who were not necessarily learnt in the domain of composition, sought to make music as a means of expressing themselves in a way which was not sophisticated, but permitted them to exteriorize their feelings by creating music without writing it on a score. This was a style in whose elaboration improvisation as explained in the second part of the present work, became the prominent part. This style of music, was jazz. The jazz musician would often be in solo with his instrument, trumpet, saxophone, or piano, or join other musicians to form a band. The use of chord progressions is the most important method in jazz improvisation, and would allow the musician to make a long and varied piece out of a simple melody. In America, one of the greatest composer of jazz music was George Gershwin, who succeeded, in his genial *Rhapsody in Blue*, a work for piano and orchestra – like a one-movement piano concerto – in mingling twentieth century post-romanticism with the newly appeared jazz style. Gradually in the latter part of the twentieth century broadway music appeared, largely brought about by that same inspiration which had created jazz.

Apart from later composers of atonal music, at the dawn of the twentieth century, Russia seems to have become the finest producer of musicians, particularly composers. Piotr Illych Tchaikowsky had been the greatest Romantic Russian composer in the second half of the nineteenth century, and his profoundly dramatic music imbued with a depth of suffering which even the considering of his own difficult life can hardly explain, certainly represents the greatest musical legacy of the giant of the East. Six symphonies, the last of which, nicknamed « Pathetic », is the most famous, a splendid 1812 Overture – written for the celebration of Napoleon's defeat over the invasion of Russia – two piano concertos, an opera, and most of all his three ballets, *Swan Lake*, *The Nutcracker* and *The Sleeping Beauty*, form the most important part of his greater output.Tchaikowsky's ballets epitomize Classical ballet, at a time when it had freed itself from its dependance on opera, with which it had always competed. At the time of Romantic ballet (which, contrarily to the application of the term to music, preceded Classical ballet), danced

sequences were an integrant part of opera and served as divertissements, and later French ballets, like Hérold's *La Fille mal gardée*, or Delibes' *Coppélia* still conserved the abundant use of pantomime and the importance of the décor. Tchaikowsky gave ballet an unprecedented dramatic range and a depth which still moves and astonishes audiences, his three ballets remaining favourites in the repertoire. The success of the two last, *The Sleeping Beauty* and *The Nutcracker*, was immediate and the failure of the first, *Swan Lake*, at its premiere in 1877, was fantastically surmounted by Tchaikowsky's association with the choreographer Marius Petipa, who encouraged him to present the work again in its improved version. The success of this third ballet affirmed Tchaikowsky's reputation as probably the greatest and most loved ballet composer – the importance of these three works among the others of the repertoire testify that he excelled in the genre, which allowed him « to try something different, more feeric », to take up his own words – and assuredly the greatest Russian composer of all times.

But towards the end of the nineteenth century a new group of nationalist Russian composers emerged. They called themselves « The Mighty Handful » and were Milij Balakirev, César Cui, Modest Mussorgsky, Nicolai Rimsky-Korsakov, Alexander Borodine – the « Group of Five » – and Glinka and Dargomijsky. Each of them wrote fine pieces, and Mussorgsky's *Pictures at an Exhibition*, Rimsky-Korsakov's symphonic suite *Schéhérazade* (which shows his gift for orchestration) and Borodine's opera *Prince Igor* remain favourites today.

At the dawn of the twentieth century ballet took a new start with Sergei Prokofiev and Igor Stravinsky, whose works explore the new tonalities and methods of composition which were the discoveries of the era. The arrival of Diaghilev, the ballet impresario, around 1905 launched a renewal of ballet which saw the apogee of the Ballets Russes, Russian Ballets, a term created to refer to Diaghilev's ballets, and consequently, to the ballets danced on the music of those modern composers. While Prokofiev's style (*Cinderella*, *Romeo and Juliette*) is characterized by a high originality which genially blends the traditional scales with chromatic and dissonant tones to create a powerful emotional impact, Stravinsky's ballets, *The Firebird*, *Petruschka*, *The Rite of Spring*, are mostly examples of the largely innovative atonal music of the modern era.

Simultaneously, at this time when it began to enter in popular belief, that all the resources of tonal music had been exploited, and that no more melodic combinations were possible in the traditional scales, and

that the future rested in atonal and serial music, some composers still had a hope that tonal inspiration was inextinguishable, and that infinite melodies and harmonies could still be found. These composers regarded with dismay and indignation the discoveries of the new avant-garde artists of the day in atonality and continued, amidst an ever growing tension, to write with marvellous inspiration in the tonal tradition of their predecessors. Such composers were Sergei Rachmaninov, Alexander Glazunov, and others who were characterized by the same faith in the never ending existence of tonal inspiration. Of the two Rachmaninov is the most known, and his symphonies, piano concertos and virtuosic *Rhapsody on a Theme of Paganini*, which significantly looks to the past by taking the theme of Paganini's famous last Caprice, all bear the stamp of Russian melancholy and a typical kind of sadness evoking the end of Romanticism. Mostly known as a virtuoso pianist, whose large hands enabled him – like Liszt – to cover impressively great intervals on the piano, he also left many solo works for the instrument. And in his second piano concerto one feels the anguish, the nostalgia, but also the glory, of a work which seems to have been intended, as a last reverence and farewell to three centuries of divine inspiration, which have left to us, audiences of the future, through tragedies, conflicts, and passion, one of the greatest treasures of human endeavour.